Looking for Shells

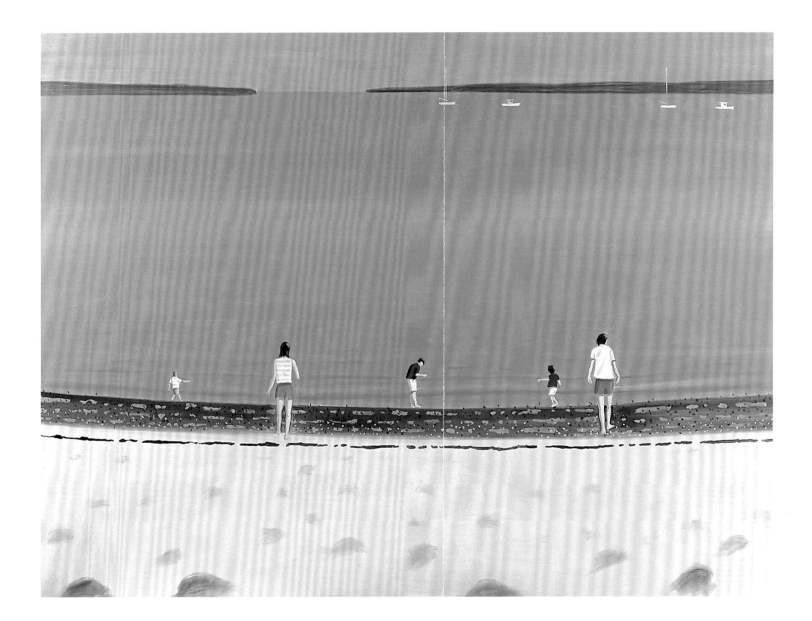

10:00 pm

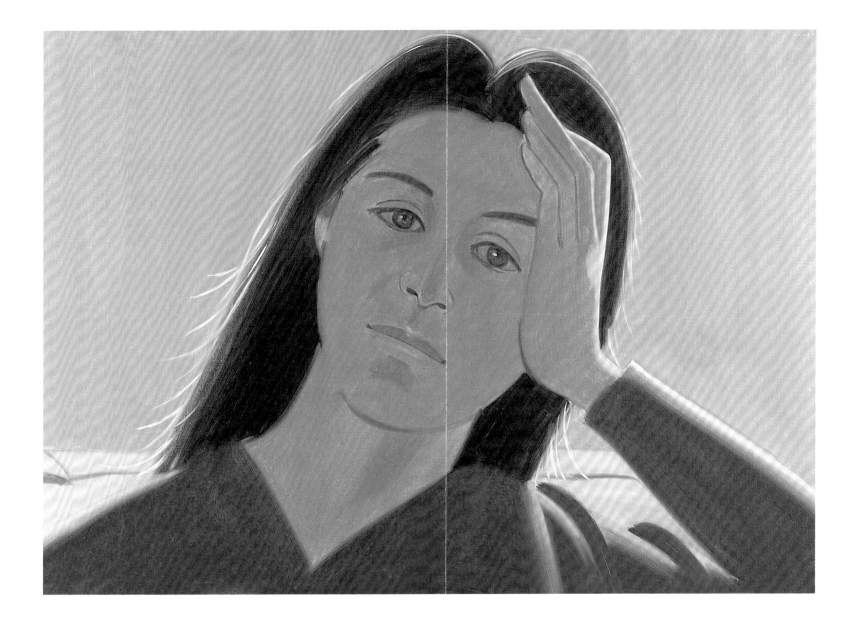

Ada & Luisa

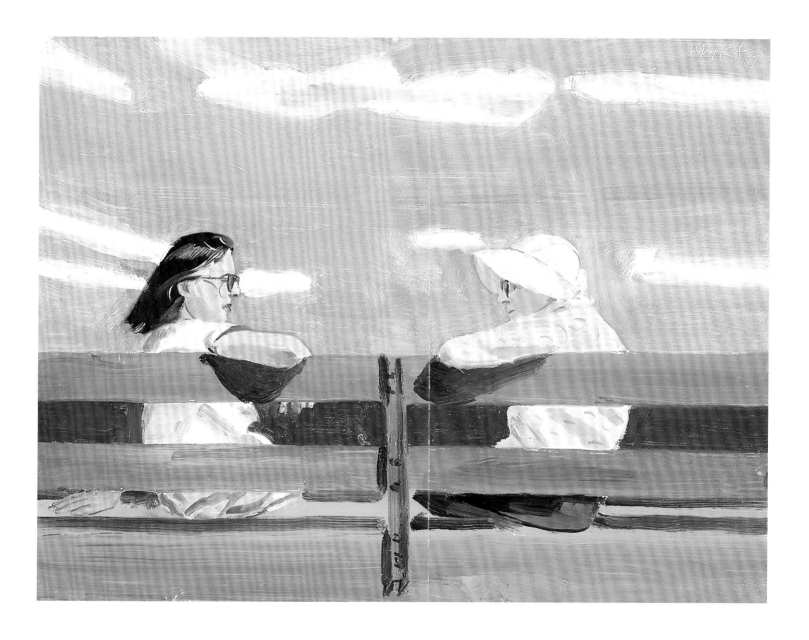

Vivien

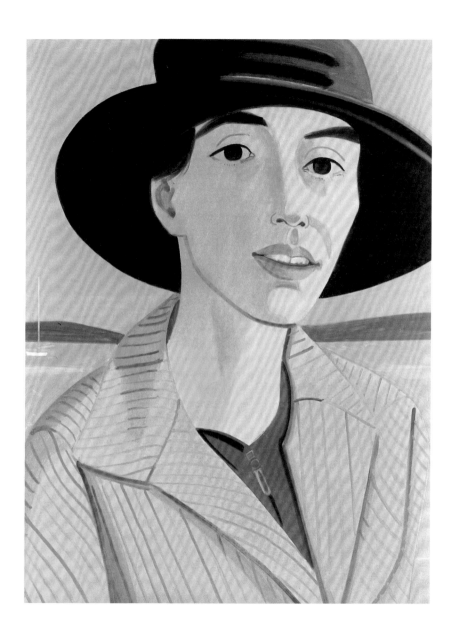

Birthday Party

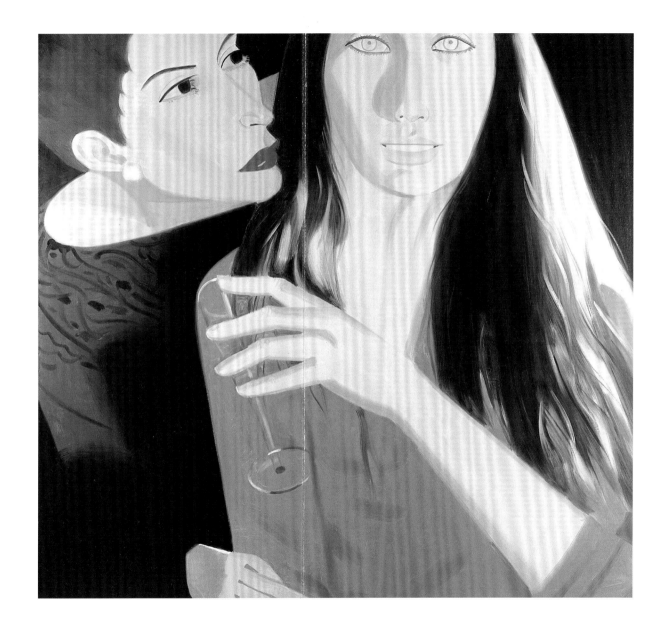

St. Petersburg

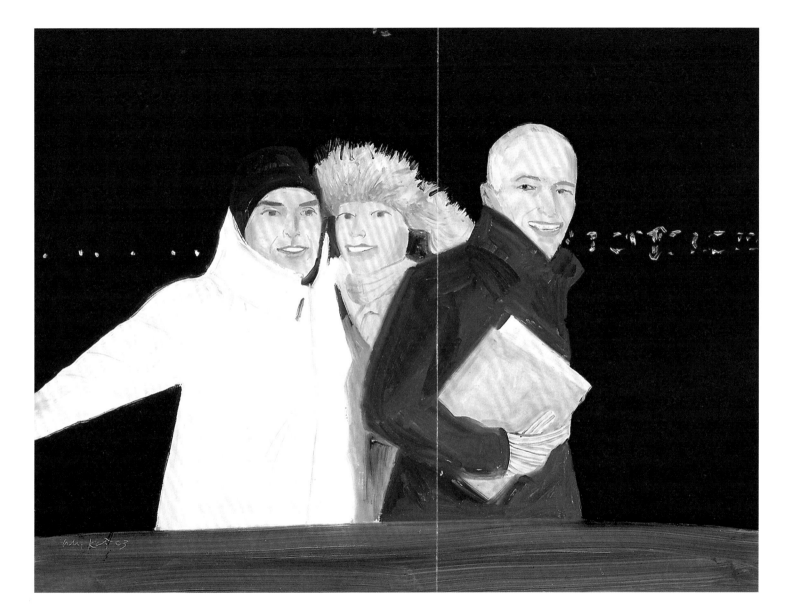

ALEX KATZ

FACE OF THE POET,
a portfolio of fourteen original aquatints which were
drawn by the artist on copper plates between January
and June, 1978. Etching, proofing and editioning by
Prawat Laucheron, New York. Each print bears the blind
stamp of the printer. The paper is J. Green Hotpress
torn to 14½ x 19 inches (368 x 483 mm). The prints
are signed and numbered by the artist.

To accompany the portrait, each poet has contributed
a poem. These are set in 14 point Baskerville and
printed letterpress. Typesetting and printing by
Tri-Arts Press, New York. The paper is Hodgkinson
handmade White Wove.

The portfolio consists of 28 unbound pages plus a
colophon and title page. It is contained in a box
made for this work by Takumi Nishio, New York.

The portfolio is published as:

| an edition of twenty-five | 1/25 – 25/25 |
| ten artist's proofs | A.P.1/10–A.P. 10/10 |

Published by:

Brooke Alexander, Inc.	Marlborough Graphics, Inc.
20 West 57th Street	40 West 57th Street
New York, New York	New York, New York

THE PEARS ARE THE PEARS

the pears are the pears
the table is the table
the house is the house
the windows are the windows

the car is the car
the roads are the roads
the streets are the streets
the white line is the white line

the curves are the curves
the thigh is the thigh
the knee is the knee
the arms are the arms

the eyes are the eyes
the mouth is the mouth

Ted Greenwald

SQUATTER IN THE FOREGROUND

(for Ann Lauterbach)

We rake the past, down to an ounce of wants.
Meant to begin in haybarn dorm of overall kerchiefs,
an empire of cow sphincters on the hook by May.
I think I'll stare at the muss to endure
all I am: non-stop strands, new dues to pay up.

Air dens with leavings, fridge hum clicks off.
Nothing on the easel so nothing melts.
The story so far: pair of angels swish across grass
into dim room. Wrestlers. Big mirrors, stacks of 'em.
White walls lift. An Anglo-Saxon pause for identification.

Kanward Elmslie

LIFE

Someone comes up to me on the street
starts talking about their "love life"—
how "fucked up it is"—pushing their need.
All the cars going by flash in the sun
like kisses blown from lost loves
disappearing over the horizon of "maturity"
and I want to say "Are you kidding me?!"
But I know I can't judge anyone else's pain
even though my father's 75 this year and complained
so much longer and louder than my mother
who "passed" ten years ago, on Mother's Day,
looking startled, as though she hadn't expected
death, or god, or whatever she saw approaching
to be so heartless about it after all.
That was pain. Or the news that
my oldest sister is "going blind" just like that
and my father dumb enough to say
"When we found out you had diabetes at seven
we never expected you to live even this long . . ."
and losing the pigment in her skin so that
when statistics or simplifiers list her as "white"
they'll finally be right. Or the way that man today
waited so patiently for someone, this time me,
to come and guide his blind steps across the avenue
where cars flashed for him in ways I'll never know
and me still high on the look in the eyes
of a woman he'll never see like me. Or the news
of some money coming my way I got over the phone today
my two deaf cousins would have to wait for the mails
to hear. But maybe they should be grateful
for knowing where it hurts or doesn't hurt
or doesn't do what it's supposed to do
and feel sorry for you, or me, when we don't know
what it is that keeps us from smiling and expanding
on the grace of all that's intact and working for us
in ways that keeps us looking for "love"
as though we knew where it was all along.

Michael Lally

THE STARS

The stars are out now.
You come into the
full mesh of sunny
winter afternoons
beyond the bubble.

How can I be low
or transparent? The
thief of honey,
a winner of moons
causes the trouble.

Since Christmas I've bought
a new blue hat rack
to celebrate the loss
of your failure at
pleasing my household.

Aimless rifles caught
in a senseless act
are the double-cross
that doubles the hat
of the biting cold.

The lights are out now.
You drawl into the
cavern of money,
killing afternoons
to smash the bubble.

John Perreault

FOR STEVE ROYAL.

That wailing chorus by a tenor sax
on the radio—how it brings you back.
Too young for a legal drink, we would sneak
to the alley behind the bandstand at Patty's,
bopping our heads in time, feet pumping the
beat, to hear you through the door, anywhere
the management looked the other way
at teenage hipsters sipping expensive cokes,
bent on digging jazz—the Red Galleon
on the Post Road, or the Showboat you played
so much, so well, in Bridgeport our home town.
Your friend my teacher Tony Guzzi
would lean back from the keyboard
and set me straight on local history.
How your name really was Royal, how
what a fantastic pitcher you were as a kid
but had to stop throwing because of your heart.
You were the biggest name in the workshop band
that rehearsed on Monday night's at Bill's Castle—
factory workers, highschool teachers, house painters—
our heroes "The Jazz Giants." And when
you slid from your seat to solo, cool,
with your jaw shot out, all of us went nuts.
In '62 you went with the "Giants" to Newport;
all of us shared the thrill, to play (if only
an afternoon set) for the big Jazz Festival crowds.
We young cats followed—Albert, Bob, the three Bills,
one of whom drove with a motel turban towel
wrapped around his head, high on Cutty Sark,
screaming bop riffs as we eyeballed the pretty girls.
When Ted Curson's sax man was hurt in a wreck
Curson tapped you to fill in.
He had ears, you could make the insane tempos,
spinning out of Gets and Zoot as they flew forth
from the brains and blood of Dexter and Pres,
as even those of us who played no horn
came out of you: those deep saxophone breaths,
the world flooded with air, like being dipped
in pure atmosphere, lungs crying and singing
the truth of what it means to lay the heart bare.
But no, you couldn't stay. Your worried wife
cried. The kids waited at home, and the job.
What did we know of that? "Man," we griped,
"All Steve wanted to do was play" Sikorsky
didn't need another tenor man or overtime.
All I wanted then was music, too.
I was coming up, a few years younger than you.
I had my hands on something. One night you called
to offer me a concert at Danbury State.

You even drove me up there in your car!
Al Montecalvo would be on drums, young Lou Bruno on bass,
the best of the new players. We did "Billie's Bounce,"
that up Charlie Parker blues, and the "One Note Samba,"
and one of your favorites, "Polka Dots and Moonbeams,"
a dreamy ballad you poured your damaged breath through,
notes curling back on themselves like the smoke
from your cigarette, the curlicues of subtle gestures
I wondered how many ears caught in that college gym.
You seemed pleased with my playing. You called again
for local gigs, and in the rush or lull of a buffet
we'd slip an up-tune by them, "for the band."
How little you said, your movements precise
as your music. Short hair, in dark clothes
always, a cigarette dangling, always so intense.
When your next break came you went with Woody Herman,
whose new big band was ripping up everyone's air.
How long was it that time, six weeks? A few months
of life lived with all the stops blown out
then back you went (none of us could see why)
to the factory line and playing highschool dances.
At thirty-two, in a clipping my grandmother sent,
you stared from the newspaper, suddenly dead.
What was to blame—heart, home, job, the popular taste?
By the I'd split to the Apple to go to school, I
turned my back on the one-night stand, the pureness
of going nowhere. I was no fool, I'm still alive.
I still play the piano when I want.
In the music we loved, I know I will never be great.
I beat my fingernails flat on broken pianos
from fifteen to twenty-five. Finally I couldn't cut
those changes, soured on the drunks and silly ladies
requesting "Anniversary Waltz" that you'd perform
so graciously, stopping to flash the band your Weirdo eyebrow
as you mopped the floor with waves of Lombardo vibrato.
"Everyone dies of heart failure," my grandmother wrote to say;
a homespun contribution to philosophy
that leaves very little room for sentimentality.
Somewhere, gathering dust on some ex-musician's shelf,
is there one record or tape that preserves
the beauty of your horn? Those flushing clusters
of eighth-notes, invisible, lost in the air of an era when
(you used to sigh) "All the kids want is that rock 'n' roll."
Your beauty went begging—played the cha-cha, played
the Bunny Hop. What I can record of you, I will.
American music made at night
by a member of the white working class,
ham and eggs at the Main Line Diner, later.

Bill Zavatsky

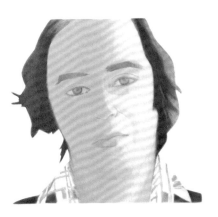

DABBLE

Dabble hours heave all muggy
with Miss Subway's sighs
In a mood like California crime
my tippling love swells nightly
in tempo abreast liberating nuisance
Skat-voiced bouquets tendered
your maternal side by
the infantile mob, and you
return a kiss, its tactile oval nudge
blown as casually as a hit
of reefer toward their reddened eyes
and myths of doe-like women—
squandered musky intent, eh legs?—
falling from sprouted whole-grain skies
Not a bedroom scene, more as if
on a fender, surrounded by the affronting
petals of dog where the *barranca* curb
hands to the river draught
the lillies of storm drains
We overlook this, but not the
vaudevillean *angst* of strays courting
invulnerable windows, parroting
sleepers' far-gone postures with
savant economy, the purest jazz

 John Godfrey, June 1976

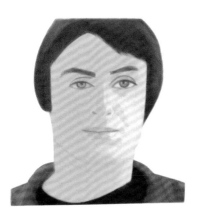

THE BUDDHA ON THE BOUNTY

"A little loving can solve a lot of things"
She locates two spatial equivalents in
The same time continuum. "You are lovely. I
am lame." "Now it's me." If a man is in
Solitude, the world is translated, my world
& wings sprout from the shoulders of The Slave
Yeah. I like the fiery butterfly puzzles
Of this pilgrimage toward clarities
Of great mud intelligence & feeling.
"The Elephant is the wisest of all animals
The only one who remembers his former lives
& he remains motionless for long periods of time
Meditating thereon." I'm not here, now,
& it is good, absence.

Ted Berrigan

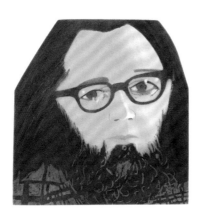

THE SEA AND THE WIND

There is no light and no quiet;
some areas are smaller than others; a shout
is not heard at once,
but makes a way in leisure to your ear,
and in a moment of leisure you hear it,
with the sound of your voice.
I do not know clearly what it is,
but now in the lime dusk I write about it,
enveloped like time in a larger facsimile.
And soon it will be louder,
until there will be no further need for notes,
or even for an end to it, having multiplied, as children
within their boundaries of sensitive particles,
in generations to languish in the respective arms of civilizations,
coming of age in China, ancient Greece, or the fabled Levant—
French for getting up—going to the bathroom
and back to bed, beset with Parisian dreams;
adrift like islands beside the American ones conceived in English,
all of them together irrigating the wide basin of simple life.
Children learn to deal with the local merchants,
and become used to it;
they go outside and give themselves up to it,
in series of events which rival an eclipse of the sun;
they go alone or with a guide far off in the night,
passing our monuments and tombs
reflecting their obviously transitory state.
Children eat too much, too many cakes and too much candy;
they have vacations, drive to the mountains and beaches
and come back; travel through forests and over boulevards,
until finally there are the continents, the oceans,
and the vastnesses of outer space
to make up the eye's foreign vision.
In the meantime they find stems together, flowers, fences,
marble. Exalted feelings and ornate cornices;
there are excursions to museums, pursuing
one another down corridors, grapes, underbrush, memories,
and Mozart concerti among the dominant points of interest,
and a gabled roof, a swooping hawk, the silver flash of a trout,
dramatic but none the less minor points,
rejoining always one's generation at the elevator,
or elevation, to the combined hallucination and dream.

 Tony Towle

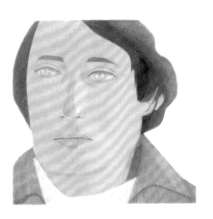

The Goddess who created this passing world
Said Let there be lightbulbs & liquefaction
Life spilled out onto the street, colors whirled
Cars & the variously shod feet were born
And the past & future & I born too
Light as airmail paper away she flew
To Annapurna or Mt. McKinley
Or both but instantly
Clarified, composed, forever was I
Meant by her to recognize a painting
As beautiful or a movie stunning
And to adore the finitude of words
And understand as surfaces my dreams
Know the eye the organ of affection
And depths to be inflections
Of her voice & wrist & smile

Alice Notley

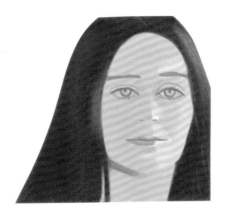

I remember the little house in the woods
surrounded by potato fields. We were so young
and thought we were so old. Max is married now
and Sam just brought out a very successful line
of oversized T-shirts. They were so beautiful
when they were little. We rented that house for
five years. Gosh it was expensive to heat.
How many houses have we gone through since then?
Our last summer there Sam broke his leg. How
could anyone fall two feet off a sofa onto a
three inch pile carpet and break a leg? But he did.
I was in Paris. Billy must've freaked. That was the
summer Fran, Mark, and Rene all spent the weekend. Hah!
Let's see. I was just getting over one of those awful
summer colds. Oh boy! Rene disapproved of half the world
and Fran disapproved of the other, and, hah, that was the
summer Mark volunteered an opinion. Boy did we laugh.
What a job moving out of that place. We stole that little
mission table. I worried so much over it and the landlord
never even noticed. I haven't thought about that place in
so long. It's funny how a memory will rush up on you
for no apparent reason.
Mark's book on the 'seventies is a runaway bestseller. I'm so
glad. He secretly always wanted to be lionized. He was proud
as a peacock when Christophe invited him to dinner.
The following winter Fran moved in with us. It was
rough on Billy for awhile but he adjusted. We've
won best of breed three years in a row now. Everyone on the
ferry to the Pines has a Norwich terrier these days. Who
would've thought. Nobody's heard from Rene in so many years.
His name crops up every so often, mostly when I see Aaron.
Boy that kid's made a bundle–kid! He's 37. They were so close
That summer. I wonder what . . . Come here Lucy XV. Let me
brush you. It's funny how a memory will rush up on you for no
apparent reason. Lucy, you drab little puppy. Oh. Of course

Rene Ricard

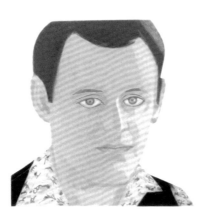

RAIN

If we met would you know me

face wet
hair wet

what stays
in the mind

as if nothing said
enough—there is nothing

the heart finds
nothing to
cling to

but what stays
in the mind

4:viii:78 nyc

for S.M.

Gerard Malanga

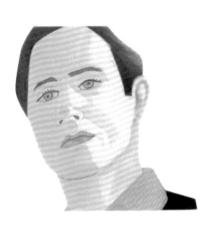

ARRIVEDERCI, MODERNISMO

Arrivederci, kiosks, jealousies, temperament.

Why isn't this so much harder than it seems to be?

"Arrivederci, temperament." How many times did we go through that? And how easy, finally, did it get? Arrivederci, accordian music, jokes about asparagus.

Arrivederci, words, rose-colored glasses. Arrivederci, passions frowning at you from the walls of other peoples' portrait galleries.

Arrivederci, foam-born, proportionate, and unapportionable . . . arrivederci, method and you, too, aleatory method. There were so many good-byes right from the very start that, strange as it is to meet you once again, Modernismo, it isn't strange to be saying, at long last, good-bye, adieu, arrivederci . . . to you this time, Modernismo, dear.

Temperament wasn't the first to go—I mean, it needn't have been . . . but the cards fell that way, didn't they, Modernismo? —and that's when I fell in love.

So much had suddenly become too late and that seemed to put the future so near, so disruptively near. Our future was so early too late. I loved the way you reduced it to manageable proportions, to admiration, to a swirl of modernist periods, each one timelessly ordained. I loved your feather-boa period and the way you reduced it to your plucked-eyebrow period.

I loved the reductionism of your smile and the somnambulism of your endless pronunciamentos .

If I had anything to do with the overlapping of modernist periods, with the clumsiness of the catching up that admiration had to do, I can only say I'm sorry, Modernismo, even though this is good-bye and your reductionism is not what invigorates me now.

I loved the good-bye we arranged for bathos, and I wondered then, bathetically, if love was ever the point. Not to ask that purifying question as I'm doing now, but to live it—that was as close as I ever got to your elegance, your circularity . . .

I loved the way you painted yourself into a corner without ever lifting a brush, and the way you made fun of yourself without ever ceasing to work, morning, noon, and night. Mornings especially, Modernismo, when the seriousness poured in like light and the certitude you craved as the marble fiend his now-white dope was reducing itself further still to the certitude that I'd always loved you.

That was progress, and progress was admired. And admiration was progressing, progressing into the modernist state of being the admired. This left me excluded but more than ever in love, so you can see—can't you, Modernismo?—that I might have gotten desperate—just a little bit?

This isn't an excuse, this is good-bye, to you and to longing or a chance to explain how it was that I was unfaithful, that I loved incertitude as well, no matter how much it might be reduced in a period to come, by whatever method, even your precious aleatory method, your pearls-before-oysters method.

Yes—I loved incertitude, the unmethodical kind. And if love was beside the point, think how I felt when I found that I felt that other love. Would you have cared if you had known that you taught me to hate myself?

Never mind. I'm only trying to lend drama to an occasion for which there is no real occasion. My "other love" was just a crush on the fact that the further reduction required by incertitude required the future as well—the future I craved and you distained, much as if it had been one of your natural gifts.

Perhaps it was, dear, despairing, unnatural Modernismo. You would rise to the occasion, any occasion, and beyond. You were better than paleontology. You were better than chiffon.

In other words, I loved most of all the way you would hug yourself empty-handedly. That was in your window-seat period, then again in your Daimler period, and then again, much later, in your soft-focus I-just-want-to-take-a-walk-down-to-the-water period.

I loved that despair of yours, Modernismo, and the way you never felt it, born as you were out of the despair of the metropolis with which you had been identified, the despair at ever finding any useful work for you to do . . .

You kept on working, which was admirable. I was dazzled as by a mirror held up to the unnaturalness of your situation. Arrivederci, representationalism.

You said that, ignoring the claims that publicity, primitive urges, and the prospect of travel were making on those natural gifts of yours. Arrivederci, café where I could always find you.

Arrivederci. I was dazzled by the mirror with no perspective, no traintracks meeting, no scenery rushing past. The fact that I could see into the mirror from which I was excluded meant to me then that we would be together always. Modernist integrity seemed to require a viewer, and I thought my disembodied love was my eternal qualification.

I didn't realise that you were your own reflection. I should say, I didn't *see*—I didn't see how superfluous it was for me to see. And then I did, and you were gone, and I never got to say good-bye . . .

Yet it's true that we were together, together always, though you're the only one who knew what we meant by "always." It was "always" reduced so as to be more itself—as, for example, seeing ever more clearly, you were a vision in those days . . .

It was your white-telephone period. Enclosed by vision, vision was likewise enclosed. I never knew how you reconciled the circularity of your principles with the right-angled geometry of that white room, but I know how you stuck to your principles, how you detached that interior from the building itself and the architecture of the city with which you had become identified, and I know how you cried when we woke up and you were there—I mean, literally, you were there—and I wasn't, and I never got to say good-bye . . .

Arrivederci at last, Modernismo, dear—I was a young man in a hurry then, and I'd noticed the history we were making had gotten into a funny habit of passing us by . . . I wanted to catch up. I wanted to be more myself.

That was my learning-to-look period, and I don't imagine— whatever your current doctrine on imagination might be— that I never looked back, for I did, time and time again.

I saw myself falling in love with you at the onset of each new modernist period. With such certainty. Maybe that's why you were willing to certify the principle that all we had meant to each other meant nothing, and thus meant everything to history, and that that's what history meant. And means.

Admit it, Modernismo—your progress had a certitude that

required no future. And the history of your turning up here doesn't change things a bit. Not between us. Modernist certitudes are displaced, but only rarely do they go away. I went away for good—but here you are! And the city is still there. And I suppose the boulevards still decline to bring you into their consultations . . .

Those odd clarities to which you would return in the very early morning are surely still there, and surely they have not yet returned the compliment to you. For it was not intended as a compliment, that purified vision of yours—of you. And the mirrors the cities have become—mirrors of you—are too cluttered by an uncertain future to have found a place in your circularity, which by now, I suppose, is the mere fact of your survival.

Arrivederci, circularity, graceful survival method, swan frozen fast in ice. Can't you see that you've never changed, so that all your steadfastness through change means nothing at all? But I'm forgetting. Vision can't see—though, reduced to self-sufficient purity, it can be devastatingly visible.

The purity of modernist vision excluded the literary, even from literature. Adieu, symbolismo. You said that, and that was real purity. The willows rippling the Alpine lake were always less graceful than you. Modernismo, and the swans, more literary. The swans simply didn't belong.

Nothing did, Modernismo.

Your self-possession—but I'm forgetting. When self-possession is certain it is reduced to empty-handedness. This is not the same as empty-headedness, Modernismo, blonde évaporée et bien visible, but it does exclude the possibility of hearing what is said. You were always deafer than a swan, my dear, and more graceful and more capable of tears.

As we were to learn. Subsequently.

But I'm forgetting. I'm forgetting your cruelty, your self-imposed exile, the smell of the lake, the yellow leaves—saved from drowning but not from death—, the autumnal mistiness. All this stabs deep, deeper far than sadness, than your teary-eyed self absorption . . .

The city is far away, like the future—raggedly unlived. The future belongs to the city, no doubt, but not to its certified distillant—you, Modernismo, who have no city and no love for this lake-side weather as it works, so off-handedly, to undo your elegant certitudes.

How can I blame you? This pervasiveness, this local color, this literary impulse is making its ragged way into futures that somehow will be lived—but not by you, Modernismo. You will be stranded here, certain only that you must suffer a killing intelligibility at the hands of Nature's natural gift for symbol.

The swan is very sleepy, yet it is frozen in the ice long before sleep comes. Dawn comes, it wakes up, it shows, death comes. Later the swan is set free from the ice—but you, Modernismo, you are more yourself, more purely visible, a swan *of ice*. A vision. Vision itself, more or less.

At any rate, the light strikes deeper in you, deeper than memories of other banquets, other historic occasions, deeper than self-deception, deeper even than an ice pick, but not so deep as the elegance of certitude: you permeate our history: you are the swan of ice who melts to water whereupon to swim.

Carter Ratcliff, 1974

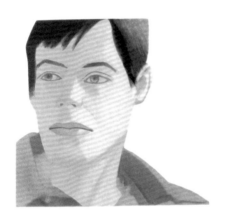

ARS

Hi

How do you like this poem so far?
If you like it, please let me know
Don't be shy, step right up
and praise me!
I need praise
Don't worry that I'll think you foolish or insincere
Even if I think that I'll appreciate your thoughtfulness
And if you don't like the poem
don't worry
Confess your dislike openly, I won't be angry
I'll be able to tell you exactly how you're wrong
It will be a big relief to both of us

And do you know? if more of you tell me precisely
what you think of me, my poem may get better!
They may get better than this one, even
Do you think poems about personal and professional and artistic
insecurity, yearning for love and approval and honest
communication, feelings of isolation, night sweats,
paranoid imaginings, hysterical loathings and doubts and
self-doubts, do you suppose writing poems on these topics is fun?
Nor are these topics among the Great Themes
to which I'm positive I'm equal, if only you
bastards would cough up some admiration, even fake it a little,
for me and my family and Art and the future of humankind.

 Peter Schjeldahl

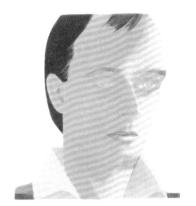

THEN SUDDENLY

The bloom, stranded somehow in glass and a view
of marvellous, slow-moving things
nameless because I had run out of names.
Measures had to be taken.
But I had been to New Jersey and back
and hadn't even noticed the bridge.
Talk is a way of not looking.
But notice how he sits in his room
without so much as a color on his mind
while at the same time light
accrues behind a mass of leaves. Now
everything is darker. I think she is on a cruise
in the Black Sea wearing her portrait
(how we see her, dream of her)
while at the same time worried about the farm.
She told me what comes to mind is
'then suddenly', an icon
for which she is never prepared but always knows.
I was trying to get at it, the way
it goes awkwardly forward on the pavement
until it takes hold, draws
out of the drive across the bridge
light strung ahead in litanies of sudden knowledge.

Ann Lauterbach

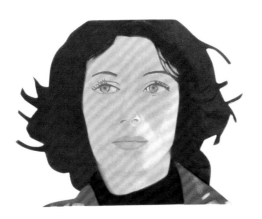

Alex Katz

Faces and Names

Demetrio Paparoni
Studio dal vero. Alex Katz

Sin dagli anni Cinquanta Katz ha condiviso con i pittori dell'espressionismo astratto la libertà del gesto pittorico. Nonostante l'impronta realista della sua figurazione, come Pollock e de Kooning si è proposto di far emergere l'inconscio attraverso pennellate veloci, attitudine che ha sempre mantenuto. Contrariamente agli artisti dell'action painting, della pop art e della figurazione degli anni Ottanta – tendenze diverse per intenti e cifra stilistica, ma accomunate dall'aver posto il soggetto in secondo piano rispetto al valore dei segni – Katz non ha mai accettato l'idea secondo cui intimismo, narrazione e simbolo denotino una pittura illustrativa e didascalica, profondamente antimoderna. Intenti narrativo-simbolici non sono totalmente assenti nell'arte del dopoguerra, negli anni Settanta li ritroviamo per esempio nella pittura dei tedeschi e in particolare in quella di Anselm Kiefer e Jörg Immendorff, ma in loro a dominare è un espressionismo di matrice socio-politica che include l'orgoglio nazionale e il desiderio di riunificazione della Germania. Katz ritiene invece che l'arte non debba mai essere subordinata al soggetto o alla storia, in modo da lasciare spazio alla dimensione simbolica. Interessato a cogliere l'essenziale in ciò che lo circonda, ha sempre rivolto il suo interesse al racconto oggettivo del proprio

Demetrio Paparoni
STUDY FROM LIFE. ALEX KATZ

Ever since the fifties, Katz has shared the freedom
of artistic action with abstract expressionists. Despite
the realism of his representation, his aim - like that of
Pollock and de Kooning - has been to bring out the
unconscious through rapid brushstrokes, and he has always
maintained this approach. Unlike the artists of action
painting, pop and the representational art of the
eighties - currents which were different in terms of
intention and style, but which had in common the way they
place the subject on a secondary level with regard to
that of the brushstroke - Katz has never accepted the
idea that intimism, narrative and symbol might be seen as
a form of profoundly anti-modern, illustrative and
didactic painting. A narrative and symbolic approach has
never been entirely absent in post-war art, and in the
seventies we can see it for example in German painting
and particularly in that of Anselm Kiefer and Jörg
Immendorff. In them, however, it is a socio-political
style of expressionism that dominates, revealing
national pride and the desire for a united Germany. Katz
on the other hand maintains that, in order to leave room
for the symbolic dimension, art should never be
conditioned by its subject or by history. In order to
capture the essence of what is around him, he has always
focused on providing an objective account of his own

universo individuale, un universo fatto di persone care, situazioni e luoghi familiari sempre segnati da una luce caratterizzante.

Come Monet, Katz è interessato a cogliere il modo in cui i raggi del sole incontrano l'oggetto e lo disegnano, a differenza di Monet però non inizia le sue tele *en plein air* per poi finirle in studio. Considerando che il paesaggio cambia aspetto istante dopo istante per l'intervento di aria e luce, Monet si concentrava sul livello più superficiale della pittura, sulla sua apparenza. La sua sfida era catturare "l'involglio", termine con cui i critici della seconda metà dell'Ottocento indicavano il modo in cui il colore muta con il mutare della luminosità. Monet ritornava sullo stesso paesaggio per registrare il variare della luce in rapporto al variare dell'ora, del giorno e delle stagioni. Registrava lo scorrere del tempo e auspicava che i suoi cicli pittorici, come per esempio i *Covoni,* fossero visti tutti insieme, in modo che tra un quadro e l'altro si potessero percepire gli scarti temporali. Anche Katz si attiene rigorosamente ai soggetti e alla luce che caratterizza un determinato momento, ma contrariamente a Monet considera questo momento nella sua unicità e rifiuta la dimensione compositiva del dipinto. Per questo affida la costruzione dell'opera alla gestualità. Da una parte si considera un pittore tradizionale perché ha un'idea del quadro

personal universe. It is a universe made of people, situations and familiar places that are dear to him and that are always marked by a distinguishing use of light.

Like Monet, Katz is interested in capturing the way rays of sunlight encounter objects and delineate them, though unlike Monet he never starts his canvases *en plein air* in order to finish them in his studio. Considering how the action of air and light changes the appearance of landscape from one moment to the next, Monet concentrated on the most superficial level of painting, which is appearance. The challenge he took up was to capture the way in which colour changes with alterations in luminosity. He returned to the same landscape to record the variations in light that occurred with changes in the time, day and seasons. He recorded the passing of time and he wanted his cycles of paintings, such as the *Haystacks*, to be seen all together, so that it would be possible to observe the shift in time between one painting and the next. Katz, too, keeps strictly to the quality of light and to the subjects that characterise a particular moment, but unlike Monet he considers this moment in terms of its uniqueness, rejecting the compositional dimension of the painting. For this reason he builds up the work by means of gestural expression. On the one hand he considers himself to be a traditional painter for he views the painting as a window on the world - on his own world - while on the other, since he views any compositional construction as academic, he brings to bear the creative capacity of action, which excludes the use of photography as the initial moment of the construction

come finestra sul mondo – sul proprio mondo –, dall'altra, ritenendo accademica ogni costruzione compositiva, mette in gioco la capacità generativa del gesto, che esclude il ricorso alla foto come momento iniziale nella costruzione della scena: i ritratti, i paesaggi e i gruppi di persone in Katz non sono mai la copia di una foto ma nascono da veri e propri studi dal vero.

Dalla seconda metà degli anni Sessanta, dopo aver provato tecniche diverse come il disegno su tela e quello su carta da spolvero riportato su tela, Katz inizia a dipingere di getto. Da quel momento ogni suo lavoro è preceduto da diversi studi a olio, realizzati all'aperto su piccole tavolette di masonite, di solito 25×30 centimetri e preparate con un'imprimitura a base di gesso. Quando il soggetto è centrato e la cifra stilistica corrisponde agli obiettivi prefissi, realizza in studio una versione di grande dimensione. Mentre lavora alla tela finale non guarda i lavori preparatori, che in qualche modo sono l'equivalente dell'allenamento dell'atleta prima della competizione.

Contestualmente agli studi su tavola, Katz si dedica alla preparazione dei colori e alla scelta dei pennelli più adatti al tipo di costruzione formale e all'ampiezza dei gesti. Ogni pennellata risponde infatti a precise regole, anche per via della tecnica del

of the scene. In Katz, portraits, landscapes and groups of people are never taken from photos but always come from actual life studies.

From the second half of the sixties, after he had tried out a number of different techniques such as drawing on canvas and pouncing paper on canvas, Katz started painting impulsively. Ever since, each work is made after first creating a number of oil studies in the open air on small masonite panels, normally measuring 25 × 30 cm and primed with plaster. When he has got the subject right and the stylistic features are as he wants, he makes a large version in his studio. When he works on the final canvas he does not look at these preparatory sketches, which could be likened to an athlete's training before a race.

While he is making his masonite studies, Katz also prepares the colours and chooses the brushes most suitable for building up the particular form and for the breadth of his gestural action. Each brushstroke actually follows precise rules, and this is partly because of the fresco technique he uses, which does not allow for afterthoughts. As well as finding the exact tones, it is essential to define the density of colour, which in his larger paintings enables him to extend the brushstroke in order to achieve the degree of trans-parency he wants. This approach to the canvas turns into a sort of hand-to-hand struggle, not unlike those that were such a feature of the works made by the masters of action painting. But while these artists proceeded by adding signs, Katz works by subtraction, reducing the descriptive elements to the bare minimum. He also

fresco su fresco, che non permette correzioni. Oltre alla messa a punto delle tonalità è fondamentale definire la densità del colore, che nei dipinti di grandi dimensioni consente al gesto di estendere la pennellata in rapporto alla trasparenza voluta. Affrontare la tela diviene così una sorta di corpo a corpo non dissimile da quello che ha caratterizzato la realizzazione dei dipinti dei maestri dell'action painting. Mentre questi però procedevano sommando segni, Katz opera per sottrazione, riduce al minimo gli elementi descrittivi. Sottrae anche quando dipinge rami d'albero che si sovrappongono o fiori che a volte richiamano la pittura della Secessione viennese. Non elimina la narrazione, inevitabile quando si mostra una scena presa dal vero, ma per non forzare la lettura del simbolo annulla ogni finzione, che finirebbe per introdurre nell'opera elementi non reali. Questo spiega il carattere sereno delle sue visioni, l'assenza di drammi, la sensazione che tutto sia a posto e che niente verrà a sconvolgere la perfezione della scena. Soprattutto nei suoi dipinti non si manifesta l'attesa di un evento incombente, come per esempio accade nella pittura metafisica italiana o nel realismo americano degli anni Trenta e Quaranta.

subtracts when he paints overlapping branches of
trees or flowers, which at times recall the paintings
of the Viennese Secession. He does not eliminate
the narrative, which is inevitable when one shows
a scene taken from life, but in order not to twist the
interpretation of the symbol he erases all fiction,
which would end up by introducing unreal elements into
the work. This explains the tranquil nature of his
visions, the absence of drama, and the sensation that all
is well and that nothing will upset the perfection of
the scene. Particularly in his paintings there is no idea
of some impending event, as for example we can see in
Italian metaphysical painting or in American realism of
the thirties and forties.

What enables Katz to be narrative but not literary
is the absence of metaphysics - the way he does not
consider the image to be timeless. Paradoxically, as de
Chirico explained, being timeless means being totally
immersed in time, since each individual moment incorpo-
rates the past, present and future. Unlike de Chirico
and American realists in the first half of the twentieth
century - such as Hopper, Benson and Bellow - Katz is
interested in capturing the instant, and only the
instant. This means he does not create the scene in a way
that suggests an action before or after. In Hopper,
on the other hand, the sense of expectancy can be seen
in the composition, in the play of shadows and in the
silent dialogue that the characters establish with their
surroundings and with the observer looking at the
picture. In his paintings, nature - which is very often
sombre and full of tension - announces storms even

L'espediente che permette a Katz di essere narrativo ma non letterario è l'assenza di metafisica, il non considerare l'immagine fuori dal tempo. Paradossalmente, come ha spiegato de Chirico, essere fuori dal tempo significa esservi totalmente immersi, in quanto ogni singolo momento ingloba passato, presente e futuro. A differenza di de Chirico e dei realisti americani della prima metà del Novecento, come Hopper, Benson o Bellow, Katz è interessato a cogliere l'istante e solo l'istante, dunque non costruisce la scena in modo da suggerire un'azione che la preceda e una che la segua. In Hopper invece il senso dell'attesa si manifesta nella composizione, nel gioco delle ombre, nel dialogo muto che i personaggi instaurano con l'ambiente che li accoglie e con chi guarda il quadro. Nei suoi quadri la natura, spesso tetra e carica di tensione, preannuncia temporali anche quando la luce è trasparente come può esserlo quella del Maine. Niente di più lontano dal realismo di Katz, per nulla drammatico, le cui figure non proiettano mai l'ombra al di fuori di se stesse.

Sia Katz che Hopper cercano la bellezza. Il primo la individua nell'ambiente che lo circonda per mostrarla liberata di ogni sovrastruttura, il secondo ritiene che essa non sia nel soggetto ma che dipenda da ciò che l'artista è capace di aggiungere. Convinto

when the light is as transparent as it can be in Maine. Nothing could be further from Katz's realism, which has nothing dramatic about it, and in which the figures never project their shadows outside of themselves.

Both Katz and Hopper are in search of beauty. The former finds it in the environment around him and shows it free from any superstructure, while the latter considers that it is not to be found in the subject but rather depends on what the artist is capable of adding. Since he is convinced, for example, that the painter cannot intervene in the case of the beauty of flowers, Hopper excludes them as subjects. The same is not true of Katz, who sees in them a form of natural energy linked to the quality of vision. It is from this point of view that we need to interpret his interest in light at certain times of day and with regard to everything linked to an individual moment in time. An example of this can be seen in his series of "smiles": nothing is more changeable and linked to a particular instant than a smile.

Maintaining that it is the perspective view that establishes the composition, Katz almost always portrays his subject from the front or from the side, with little chiaroscuro. This gives them a degree of fixity that sometimes recalls Egyptian art from the time of the great dynasties of the Pharaohs, though at other times it recalls the figures of Piero della Francesca, or Manet's sitters. Indeed, he considers Manet the most interesting painter of his age for his ability to transform two people who say absolutely nothing to each other into the representation of a motionless life. Katz always makes

per esempio che il pittore non possa intervenire sulla bellezza dei fiori, Hopper li esclude come soggetto dei suoi dipinti. Non altrettanto fa Katz, che individua in essi una forma di energia naturale legata alla qualità del vedere. È questa l'ottica in cui va interpretato il suo interesse per la luce in determinate ore del giorno e per tutto ciò che è legato a un momento irripetibile. Ne è un esempio la sua serie di "sorrisi": nulla è più mutevole e legato all'istante di un sorriso.

Ritenendo che sia il taglio prospettico a determinare la composizione, Katz ritrae quasi sempre i suoi soggetti frontalmente o di profilo con un chiaroscuro ridotto. Conferisce loro una fissità che a volte rimanda all'arte egizia dell'epoca delle grandi dinastie faraoniche, altre alle figure di Piero della Francesca, altre ancora ai soggetti di Manet, che considera il pittore più interessante del suo tempo per la capacità di trasformare due persone che non si dicono assolutamente nulla nella rappresentazione di una vita immobile. Katz è attento che i suoi soggetti mantengano sempre naturalezza e, quando la postura dei corpi e la posizione delle braccia o delle gambe li fa sembrare in posa, li decontestualizza dall'ambiente, stagliandoli su un fondo monocromatico. L'espediente fa comprendere quanto sia complesso

sure his subjects appear natural and, when the position of the body or of the arms or legs makes them look posed, he decontextualises their setting, making them stand out against a monochrome background. This expedient shows how complicated it is to portray reality objectively, and especially it helps us understand how greatly the experience of the *Color Field*, mainly employed on the juxtapositions of the various areas of colour, influenced his training.

From the late fifties, when Katz started painting in flat tones – a decision that led some to think of him erroneously as a pop artist – his paintings acquired a movie-like structure. In terms of dimension, format and cut, and of the poses of his sitters, his large canvases remind one of cinema screens and the way in which they manage to show us images enlarged way beyond reality, while making them look quite natural. It was the big screen that gave him the idea of close-up faces that fill the entire canvas.

In Katz's work one can sense the artist's eye observing the scene as he paints it. This characteristic is probably one of the watersheds that separate traditional art from that of the historic avant-garde movements, even though there are plenty of artists who, while following along the lines of modernism, have never refrained from photographing reality. Katz's paintings are at once traditional and modern: they are traditional in the way they interact with the subject they reproduce, yet they are modern in the way they summarise reality on a graphic and chromatic level. Extrapolated from the figurative context of

ritrarre con obiettività il reale, soprattutto aiuta a capire quanto l'esperienza del *Color Field*, giocata principalmente sugli accostamenti tra le diverse aree cromatiche, abbia inciso sulla sua formazione.

Dalla fine degli anni Cinquanta, da quando Katz inizia a dipingere a tinte piatte – scelta che ha portato alcuni a pensare impropriamente a lui come a un artista pop – i suoi quadri hanno assunto un impianto cinematografico. Per dimensione, formato, taglio e postura dei personaggi le sue grandi tele fanno pensare agli schermi cinematografici e al modo in cui questi riescono a presentare immagini ingrandite a dismisura rispetto al reale, facendole tuttavia apparire naturali. È stato il grande schermo a suggerirgli i primi piani di volti che riempiono per intero la tela.

Nelle opere di Katz si avverte l'occhio dell'artista che osserva la scena mentre la sta dipingendo. Questa caratteristica è probabilmente uno dei tanti spartiacque che separa l'arte tradizionale da quella delle avanguardie storiche, anche se non mancano artisti che, pur muovendosi nel solco del modernismo, non hanno rinunciato a fotografare il reale. I dipinti di Katz sono tradizionali e moderni al tempo stesso: sono tradizionali nel modo in cui si confrontano col soggetto da riprodurre, sono moderni

the painting, his stylistic elements appear foreign
to the realist tradition, even though they do form part
of it in terms of social narrative. It is a story
told without judgement. Katz looks into the immobility of
life, peering into its densest moments in search
of answers. But then that is what realism aspires to:
understanding the world by reproducing it.

nel modo in cui fanno sintesi del reale sul piano grafico e croma-
tico. Estrapolati dal contesto figurativo del dipinto i suoi stilemi
appaiono estranei alla tradizione realista, nella quale però rien-
trano attraverso il racconto sociale. Un racconto senza giudizio.
Katz si interroga sull'immobilità della vita, la scruta nei suoi
istanti più densi alla ricerca di risposte. Del resto, è a questo
che aspira il realismo: comprendere il mondo attraverso la sua
riproduzione.

Looking for Shells, 2002
Olio su tela
182,9 × 243,8 cm

Negli ultimi quattro anni ho iniziato a sviluppare dei dipinti, prendendo i gesti da fotografie e la luce empiricamente. Così i gesti delle persone provengono dalle fotografie e la luce viene dalla pittura empirica. Questo quadro è stato dipinto all'inizio di questo tipo di lavoro, che ho proseguito per tre o quattro estati. Ho realizzato alcuni dipinti di grandi dimensioni di questo genere.

La luce e il colore vengono interamente dalla scena e i gesti da fotografie.

Questa è a Lincolnville Beach, nel Maine. Per un po' ho realizzato delle piccole figure in spiaggia e alcuni di questi dipinti. Sono dipinti molto completi perché sono finiti in se stessi e molto difficili da fare.

Questo è uno degli ultimi con un'immagine del genere. La marea ha lasciato delle sacche d'acqua e la sabbia è ancora scura per l'umidità, non si è ancora asciugata. Per me è molto difficile dipingere queste piccole figure … mi ci è voluto un sacco di tempo per dipingere questa.

Vedi, quella è la spiaggia. È una spiaggia corta con una marea notevole. L'acqua si alza e si abbassa di quattro, cinque metri, e se si sta alzando lascia delle specie di nervature dove la sabbia è scura. Sono le alghe portate dalla marea, che le spinge a riva.

C'è una baia che si chiama Penobscot Bay, è un nome indiano, e queste sono le isole di quella baia. Credo che questa sia Islesboro Island … ci sono delle ville per le vacanze e ci si arriva in aereo.

LOOKING FOR SHELLS, 2002
Oil on canvas
182.9 × 243.8 cm

In the last four years, I started developing paintings,
getting the gestures from photographs, and getting the
light empirically. So the gestures of the people come from
photographs and the light comes from empirical painting.
This painting was painted at the beginning of this kind of
work, which I did for three or four summers. I've done some
large paintings of this kind.

All light and colour comes from on-scene and the
gestures came from photographs.

This was at Lincolnville beach, in Maine. I was doing
small figures for awhile at the beach, and I did a bunch of
these paintings. They are very complete paintings as they
are contained and really hard to do.

This is one of the last ones with such an image. The tide
left pockets of water, and it's dark from the wet of tide,
it hasn't dried yet. For me, it's very hard to paint those
small figures - it took a lot of time to paint this.

See, that's the beach. It's a short beach with a big
tide. There's a twelve-foot tide, and if the water is
rising, it leaves brackets here, and the sand is dark.
This is all the seaweed that gathers with the tide, and the
tide pushes it up.

There's a bay, called Penobscot Bay, it's an Indian name,
and these are its islands. I think this is Islesboro Island
- people have estates on there, people fly into there.

10:00 pm, 1977
Olio su tela
86 × 122 cm

Questo dipinto è uno studio sul controluce. Se guardi i miei quadri, c'è un sacco di controluce.

È iniziato tutto con un dipinto intitolato *Sylvia*, nel 1962-1963. È un tema ricorrente. È molto difficile trovare il colore giusto. È una specie di crepuscolo. In questo caso mi è sembrato di trovare i toni giusti. Vedi, ha un cromatismo molto smorzato. Così la pelle sembra dipinta col fango, ma resta comunque un colore, per quanto smorzato.

Fondamentalmente quando dipingi una cosa in questo modo lavori con colori che assomigliano al fango. E interagendo tra loro quando li metti sulla tela, questi colori si trasformano in pelle e ombra. È molto complicato, molto difficile.

Però alla fine sono riuscito a trovare i toni che stavo cercando.

10:00 PM, 1977
Oil on canvas
86 × 122 cm

This painting is a study of backlight. If you look at my
paintings, there's a lot of backlight.
 And it starts with a painting called *Sylvia*, from
1962-1963. It's a recurring theme. It's very hard to get the
right colour. It's a dusk kind of thing. I thought
it was really successful looking for the tones. You can
see, it's very low-chroma. So the skin seems to be painted
in mud, but you still want it to be a colour, although
very low-chroma.
 Basically, when you are painting something like this,
you're painting it with colours that look like mud. And
because of the relationship, they turn into skin and shadow
when you put these colours on canvas. This is extremely
tricky and very difficult.
 I was finally successful finding the tones I was
looking for.

Ada & Luisa, 1987
Olio su tavola
30,5 × 40,5 cm

Queste sono Ada e sua madre Luisa. Il bozzetto è venuto molto bene. Il grande quadro (183 × 244 cm) si trova in Spagna.

È un dipinto di Lincoln Road Beach. Noi viviamo a circa tre miglia dalla spiaggia. Ho frequentato la scuola d'arte nel Maine, mi piaceva abbastanza, e siamo rimasti in zona. Noi tre abbiamo deciso di comprare una casa. E poi l'abbiamo sempre tenuta.

(Indicando il dipinto) Dietro di noi c'è un parcheggio, poi passi sulla sabbia e c'è la spiaggia, quella che hai visto nell'altro quadro. È una spiaggia molto piccola. Ci andiamo tutti i pomeriggi.

Questo quadro è precedente all'altro con le figure piccole.

Questo studio credo sia del 1987. Ha vent'anni – un bozzetto di vent'anni – è affascinante.

Questo faceva parte di un ciclo. Potrei tornare ancora nello stesso posto, solo per dipingere delle marine. Credo che quest'estate dipingerò molto lì. Certe estati lo faccio, altre no... continuo a spostarmi.

ADA & LUISA, 1987
Oil on panel
30.5 × 40.5 cm

This is Ada and her mother Luisa. The large painting, the
183 × 244 cm, is in Spain. The sketch came out really good.

It's a painting of Lincoln Road Beach. We live about
three miles from the beach. I went to art school in Maine,
I kind of liked it, and we hung around. The three of us
decided to buy a house. We've had it ever since.

(Pointing to the painting) There's a parking lot behind
us, then you go down to the sand, and there's the beach,
which you saw in the other painting, it's a very small
beach. We go every afternoon.

This painting is earlier than the other one with the
little people.

This study is from 1987, I think. It is twenty years
old – a twenty-year-old sketch – that's amazing.

This was part of a cycle. I may go to the same place
again, just to paint marines. I think I'm going to paint a
lot there this summer. Some summers I do, some I don't –
I sort of move around.

Vivien, 2003
Olio su tela
183 × 152,4 cm

Questa è Vivien, mia nuora. La ritraggo abbastanza spesso. Vivien è sempre nei paraggi ed è bella, per cui sono due punti a suo favore.

Credo che questo sia un bozzetto per un dipinto più grande. Appartiene a una serie di ritratti di cappelli da donna che ho esposto a Venezia.

Alcune cose sembrano portare ad altre, e altre invece no. Le serie diventano come variazioni di una scena. Dipende tutto da come riesci a dipingerle e alla fine, quando hai ottenuto un risultato davvero buono, non è più interessante, e allora mi fermo. Per me è una questione intuitiva.

VIVIEN, 2003
Oil on canvas
183 × 152.4 cm

This is Vivien, my daughter-in-law. I paint her quite
often. Vivien is around and she's quite beautiful, so she
has two things going for her.

I imagine this is the sketch for a large painting.
It belongs to a series of women's hats, which was shown
in Venice.

Some things seem to lead to other things, others don't.
Series become like variations of a scene. It's about how
well you can paint it and finally it becomes, when it is
really good, no longer interesting, and then I stop. I deal
with it intuitively.

Birthday Party, 1990
Olio su tela
182×198 cm

Questo è uno strano dipinto. È un grande quadro ispirato a una scena di una festa di compleanno. Era il compleanno di questa signora *(indica il lato sinistro)* e qualcuno ha fatto delle foto. Gli scatti mi sono sembrati molto interessanti così ho chiesto alle due donne di venire al mio studio e posare per me. Loro hanno posato per questo quadro, io ho fatto un disegno e poi ho fatto un cartone e l'ho dipinto.

Io dipingo il mondo che ho attorno. La maggior parte delle scene di feste che ho dipinto sono nate da bozzetti che ho fatto per registrare delle posture, e poi le persone sono venute a posare con quelle posture. Ma ci sono problemi diversi e soluzioni diverse.

Le signore di questo dipinto sono Ann Lyon e una sua amica che all'epoca faceva la modella. Ma poi ha voluto fare l'attrice… suo padre era un regista. Sono entrambe francesi, è per questo che si conoscono.

Ann Lyon ha un grande gusto per i vestiti… l'ho dipinta molto. Ha fatto un sacco di cose, soprattutto nell'ambito della moda, delle riviste e roba del genere. Credo sia una *stylist*.

BIRTHDAY PARTY, 1990
Oil on canvas
182 × 198 cm

This is a strange painting. It's a large painting that comes from a scene at a birthday party. It was this lady's *(points to left side)* party, and someone took photos there. The snapshots seemed very interesting and so I asked the two women to come to my studio and pose. They posed for this, I made a finished drawing and then I made a cartoon and painted it.

I paint the world around me. Most of the party scenes I've done were generated from sketches that I made to record the gestures, and then the people came in and posed in those gestures. But there are different problems and different solutions.

The ladies in this painting are Ann Lyon and a friend of hers who was a model at the time. But then she wanted to make movies - her father was a director. Both of them are French, that's how they know each other.

Ann Lyon has great taste in clothing - I painted her a lot. She was involved in various things, mostly to do with fashion, working in magazines and stuff like that; I think she's a stylist.

St. Petersburg, 2003
Olio su tavola
45,5 × 60,5 cm

Questo è uno schizzo per un grande dipinto. È a San Pietroburgo, sul ponte, di fronte all'Hermitage. Questi siamo io, Sarah e David Salle.

Due anni fa siamo stati invitati a parlare all'Hermitage. All'inizio avevano scelto pittori più giovani, Cecily Brown, David e Philip Taaffe. E hanno detto che avrei dovuto andarci: "Dovresti portare Alex".

L'immagine del ponte viene da Munch. Lui ha dipinto tre persone sopra un ponte, è un quadro che mi piace.

Venti o trent'anni fa avevo già fatto un dipinto con tre persone. E questo è ancora lo stesso tipo di immagine.

Io trovo che David sia un pittore molto interessante. Da un punto di vista formale i suoi colori sono ottimi, e il soggetto, le immagini, sono quasi ipnotiche. Abbiamo molto in comune anche per quanto riguarda la cultura, il teatro e anche la danza.

ST. PETERSBURG, 2003
Oil on panel
45.5 × 60.5 cm

This is a sketch for a large painting. It's in
St. Petersburg, on the bridge, opposite the Hermitage.
This is me, Sarah and David Salle.

Two years ago we were invited to talk at the Hermitage.
Initially, they had picked younger painters, Cecily Brown,
David and Philip Taaffe. And they said I should come:
"You should bring Alex".

The bridge image comes from Munch. He painted three
people on a bridge, which I liked.

Twenty or thirty years ago I already did a painting of
three people. And this is again the same kind of image.

I find David a very interesting painter. Formally, his
colours are very good, and the subject matter, the images,
are almost kind of arresting. We have a lot in common in
culture and theatre, and in dance, too.

Face of the Poet, 1978

Portfolio di 14 acquatinte

41 × 48,5 cm cadauna

Queste stampe sono acquetinte degli anni Sessanta. Le immagini sono ritagliate e stampate in modo da non presentare segni di scanalature. Questo lavoro si intitola *Face of the Poet* ed è stato divertente da realizzare.

Il MoMA ha una serie di tredici ritagli di poeti e ogni ritaglio è alto quindici centimetri. Insieme, distribuiti sulla parete, formano un'opera lunga quattro metri.

Io penso vi siano quattordici poeti e la stessa serie al momento è esposta a Dublino. A Dublino mi hanno definito il pittore della città di New York. Nella mostra ci sono molte scene notturne e molti poeti. E l'ultima parte del catalogo è tutta poesia.

Anche questa serie era accompagnata da poesie scritte. Ogni poeta ha scritto una composizione originale oppure ne ha scelta una che aveva già scritto.

I poeti ritratti nelle stampe erano miei amici. Negli anni Sessanta l'ambiente della poesia sembrava più interessante di quello dell'arte, così io vedevo un sacco di poeti. Era un bel panorama sociale, un sacco di feste e di poesie eccezionali. Tutti pubblicavano delle riviste e ci divertivamo tantissimo.

Adesso però non sono più molto in contatto con i poeti. Alcuni in effetti sono morti.

FACE OF THE POET, 1978
Portfolio with 14 aquatints
41 × 48.5 cm each

These prints are aquatints from the sixties. The images
are cut out and printed so they don't have a gutter mark.
This piece is called *Face of the Poet*, and was fun to do.

MoMA has a series of thirteen cut-outs of poets
and each cut-out is six inches tall. Together, spread on
the wall, they form an eighteen-foot long piece.

I think there are twelve poets, and the same series
is actually being shown in Dublin at this time. In Dublin,
they called me the painter of the city of New York. The
show has a lot of night scenes, and a lot of poets. And the
last part of the catalogue is all poetry.

This series also came with written poetry. Each poet
wrote an original piece, or picked out a piece that he had
already written.

The poets in the prints were friends of mine. In the
sixties, the poetry scene seemed to be more interesting
than the art scene, so I've seen a lot of poets. It
was a big social scene, lots of parties and great poetry.
Everyone was doing periodicals and we really had a lot
of fun.

But I'm not too much in touch with the poets anymore.
Some of them are dead actually.

The first guy in this catalogue is Rene Ricard. He's
a poet, and he also wrote some art criticism, and some very
good essays. But he wrote very little. Ann Lauterbach

Il primo tizio di questo catalogo è Rene Ricard. È un poeta e ha scritto anche della critica d'arte e qualche ottimo saggio. Però ha scritto pochissimo. Ann Lauterbach, ha un sacco di talento. Peter Schjeldahl all'epoca era un poeta, anche abbastanza bravo. Carter Radcliff. Gerard Malanga, che lavorava con Andy Warhol. Questo è Kenward Elmslie. Alice Notley, era sposata con Ted Berrigan e più tardi con Douglas Oliver. Ted Greenwald. John Perrault... è un poeta ed è diventato critico d'arte per un po' e poi si è messo a insegnare. Questi sono Ted Berrigan, Tony Towle e John Godfrey. Michael Lally è diventato un attore e scrisse un bel poema pacifista. L'ultimo è Bill Zavatsky. Credo lavori in università.

Tutto qui.

has an ingenious gift. Peter Schjeldahl was a poet at the
time and quite a good one. Carter Radcliff. Gerard Malanga
who worked with Andy Warhol. This is Kenward Elmslie.
Alice Notley, she was married to Ted Berrigan, then later
to Douglas Oliver. Ted Greenwald. John Perrault - he's
a poet and became an art critic for awhile and later
a professor. These are Ted Berrigan, Tony Towle and John
Godfrey. Michael Lally became an actor and then wrote
a great anti-war poem. The last one, Bill Zavatsky -
I think he became an academic.
 That's it.

01076 8476

Faces and Names

Looking for Shells	Olio su tela · Oil on canvas · 182,9 × 243,8 cm · 2002
10:00 pm	Olio su tela · Oil on canvas · 86 × 122 cm · 1977
Ada & Luisa	Olio su tavola · Oil on panel · 30,5 × 40,5 cm · 1987
Vivien	Olio su tela · Oil on canvas · 183 × 152,4 cm · 2003
Birthday Party	Olio su tela · Oil on canvas · 182 × 198 cm · 1990
St. Petersburg	Olio su tavola · Oil on panel · 45,5 × 60,5 cm · 2003
Face of the Poet	Portfolio di 14 acquatinte · Portfolio with 14 aquatints · ognuna · each 41 × 48,5 cm · 1978

Succursale BSI SA
Corso S. Gottardo 20 · 6830 Chiasso

Alex Katz è nato a Brooklyn, New York, nel 1927.
Vive e lavora a New York · Alex Katz was born in
Brooklyn, New York, in 1927. He lives
and works in New York.

BSI Art Collection · Lugano
 via Peri 23 · 6900 Lugano
 Switzerland
Curatore · Curator · Luca Cerizza
Coordinamento · Coordination
 Silvia Panerai, Raffaele Züger
Contatto · Contact
 bsi-art-collection@bsi.ch
 www.bsi.ch/bsi-moments

A cura di · Edited by · BSI Art Collection

Testi · Texts · Alex Katz (raccolti da
 compiled by · Tiffany Hunold)
 Demetrio Paparoni

Traduzioni dall'inglese all'italiano
 Translation from English
 into Italian · Simon Turner

Redazione testi italiani e coordinamento
 editoriale · Editing Italian texts
 and Editorial Coordination
 Federica Cimatti

Redazione testi inglesi · Editing
 English texts · Emily Ligniti

Progetto grafico e impaginazione
 Visual Concept / Graphic Design
 Michael Heimann, groenland.berlin

Produzione · Production
 Tipografia Torriani SA, Switzerland

Separazione colore · Colour Separation
 max-color, Berlin

Crediti fotografici · Photo Credits
 Agostino Osio, Alexandre Zveiger
 Ritratto · Portrait Alex Katz
 (dettaglio · detail) Vivien Bittencourt

Un ringraziamento a · Thanks to
 Seanne Hanke

010768476

Numero di copie · Number of copies
1500
Edizione · Edition · 2007

© 2007 BSI Art Collection

Distribuzione · Distribution
JRP | Ringier
Letzigraben 134
8047 Zurich
Switzerland
T +41 (0)43 311 27 50
F +41 (0)43 311 27 51
info@jrp-ringier.com
www.jrp-ringier.com

ISBN: 978-3-905770-79-7

Stampato in Svizzera
Printed in Switzerland

Nella stessa serie
In the same series

All Around All
ISBN: 978-3-905701-51-7

John Armleder
ISBN: 978-3-905701-46-3

Robert Barry
ISBN: 978-3-905701-48-7

Daniel Buren
ISBN: 978-3-905701-49-4

Tony Cragg
ISBN: 978-3-905701-91-3

Liam Gillick
ISBN: 978-3-905701-47-0

Ils sont peintres
ISBN: 978-3-905829-23-5

Maps and Legends
ISBN: 978-3-905829-13-6

Daniel Roth
ISBN: 978-3-905701-92-0